A CENTURY OF
HAIRSTYLES

Published in Great Britain in 2014 by Shire Publications Ltd,
PO Box 883, Oxford, OX1 9PL, UK.

PO Box 3985, New York, NY 10185-3985, USA.

E-mail: shire@shirebooks.co.uk www.shirebooks.co.uk

A CIP catalogue record for this book is available from the British Library.

Shire Century no. 2. ISBN-13: 978 0 74781 372 9

Pamela Church Gibson has asserted her right under the Copyright, Designs and Patents
Act, 1988, to be identified as the author of this book.

Designed by S. Larking and typeset in Swiss 721.

Printed in China through Worldprint Ltd.

14 15 16 17 18 10 9 8 7 6 5 4 3 2 1

A CENTURY OF
HAIRSTYLES

PAMELA CHURCH GIBSON

CONTENTS

INTRODUCTION

Changing our hairstyle is the simplest and most effective way to transform our appearance – and we take for granted the fact that we can cut, colour or curl our hair as and when we want. A hundred years ago, however, all respectable women wore their long hair pinned up. To venture outside the home with hair hanging loosely over their shoulders would have been very shocking and suggestive of loose morals. And hair dye, like make-up, was still more disreputable; both were used only by actresses and courtesans. Most men wore their hair short and neat, for 'fashion' was in those days regarded as female territory. The Victorian dandies, of course, had their long locks – but from the turn of the century onwards, longer hair for men was for many years seen as a sign of 'artistic' leanings.

The twentieth century would change all these fixed ideas. Young men would start to enjoy and to follow fashion; across the decades they would grow their hair long or shave it close to the scalp, bleach or colour it, even 'perm' it. Women, by contrast, cut their hair short when society changed radically, during and after the First World War, and they gradually acquired new freedoms. As the century unfolded, they began to copy the hairstyles of women in the public eye. The cinema, then in its infancy, offered ordinary working women a chance to see fashionable clothes, worn by the Hollywood stars they came to admire. They might not be able to afford the extravagant gowns they saw on screen, but hairstyles were easy to copy – as was make-up. Worn by all actors and actresses in the days of silent film, it was soon on sale everywhere.

The new century saw technical innovations in the sphere of hairdressing; new ways of curling and colouring the hair were introduced. Later in

the century the small screen would offer other styles to emulate. And of course there have always been singers, dancers, and society beauties – the 'celebrity culture' of today is not entirely new. The dominant celebrity hairstyle of today for women is hair worn long and loose – short hair is now the exception. Yet we can reflect that in the 1960s, just as long hair was becoming ubiquitous, one of the most iconic of all styles appeared. Our cover image is a late example of this clean, short but feminine cut. Model Twiggy's haircut was created by top London stylist Leonard in 1967. Just a year previously her career was launched when he cropped her hair at the behest of her boyfriend and manager Justin de Villeneuve. She was then made the subject of a feature in the *Daily Mail* newspaper and the bookings began. Here, a year later, Leonard has modified his original cut with a couple of nods to the past. The waved sides recall the kiss curls of the Twenties, while at the nape of her neck we see what is surely a reference to the 'duck's arse' of the Fifties. Retro styling is not new and the fashions of today can always be overturned or refreshed.

The following pages show the reader snapshots of the tremendous variety of different hairstyles over the last century, many of them iconic both in their day and beyond. As attitudes have changed so have hairstyles; now variety seems here to stay, with everyone from the rich and famous to the average underpaid citizen able to experiment with new styles as well as stick with old favourites. But celebrity culture has recently imposed a worrying new uniformity – long, glossy manes are seemingly everywhere in the public eye. Hopefully vibrant self-expression will never be swept aside – or buried beneath Dynel extensions.

Camille Clifford, Gibson Girl

This Edwardian 'Pompadour' style, shown off here by stage star and pin-up girl Camille Clifford, gives an idea of the high-maintenance fashions of the era. The ministrations of a maid were essential in order to 'dress' this hair, just as they were needed to help fashionable women into the many complex layers of clothing that constituted their 'toilette'. Endless pins – not to mention carefully concealed pads – were used in the construction of this high-piled hairdo. This style was, in fact, a clear display of class and status.

The image also shows us clearly how the recognised 'beauties' of the time can seem to a modern eye mature and even matronly. Camille Clifford was in her twenties when she posed for this photograph and had won a competition to find a living version of the 'Gibson Girls' seen in contemporary illustrations. These imaginary women, created in line drawings by the American Charles Dana Gibson, dominated the illustrated papers and magazines of the time. But if Edwardian fashions were often a display of wealth and sophisticated elegance, the events of the next decade would see this put aside in favour of a focus on youth.

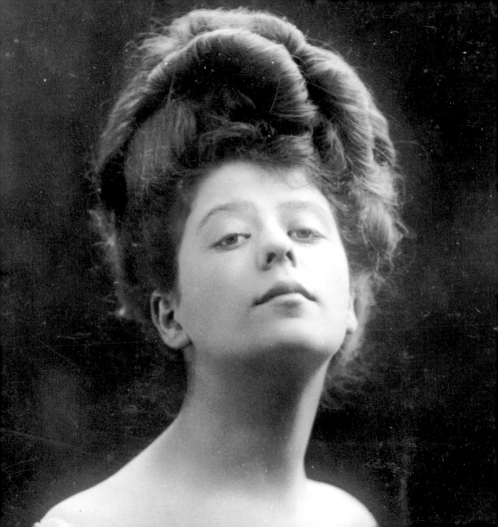

Irene Castle and the Bob

Short hair – and the fringed 'bob' haircut still popular today – is usually thought to have become fashionable in the 1920s along with short skirts, fringed dresses and the Charleston. However, its origins are in the Edwardian era of elaborately styled hair. Eve Lavallière was the most popular actress in Paris – celebrity endorsement is not new – and she lent her name to scents, soaps and shampoos. In 1909, the top Parisian hairdresser Antoine (*aka* Antoine de Paris) cut her hair short for a particular role in which it was important that she look younger than her years. Four years later, on the brink of the First World War, the American ballroom dancer Irene Castle, seen here pictured with her pet monkey Rastus, cut her hair short because it was more practical for dancing, particularly for the tango, which she popularised. It is rumoured that she cut her hair herself, and women on both sides of the Atlantic would do the same during the war years when they went out to work, many for the first time. During those years, women worked on the land and in munitions factories to aid the war effort; most enjoyed this taste of social and economic independence. Short hair was an integral part of these new freedoms and would dominate the next decade.

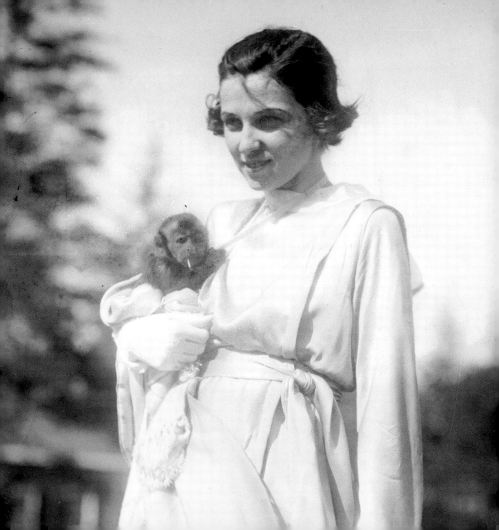

Madame C. J. Walker, Entrepreneur

Daughter of an impoverished sharecropper, Walker became the very first self-made woman millionaire anywhere in the world after she devised a system for the treatment and conditioning of black hair. Hot combs were already on sale in department stores, as were products targeted at black women before Sarah Breedlove (who later became Madam Walker) started work in the very first years of the last century for Annie Malone, whose Poro brand was already successful with African-American women. As Madame Walker she later developed and marketed her very own products, which involved the conditioning of the hair through the use of preparations she had created. The 'Walker System' that became so spectacularly successful involved these products deployed in conjunction with a hot comb; in the 1920s, the African-American cabaret star Josephine Baker would praise the Walker System. The entrepreneur set up factories and laboratories, trained 'Walker Agents' who sold and explained her system door-to-door and created a thriving mail-order business.

The philanthropic Madame Walker was also determined that other African-Americans might profit from her own success story and made a considerable number of bequests and endowments, while providing substantial financial help for the newly founded National Association for the Advancement of Coloured People. Her company also successfully patented permanent wave equipment to make wavy hairstyles last longer.

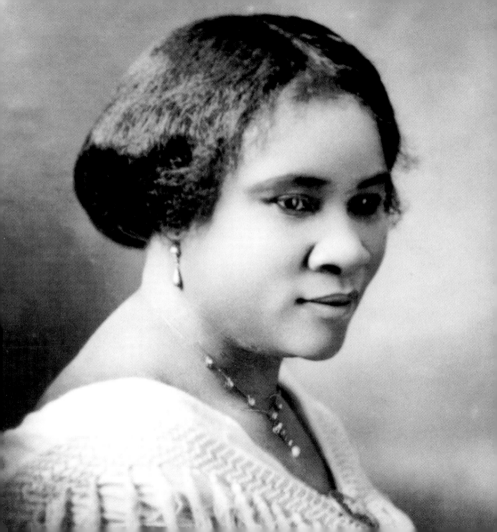

Rupert Brooke's Long Hair

The young poet Rupert Brooke died of fever in Greece in 1915. Before his death he published his five 'war sonnets', in which he welcomed a war that he hoped would sweep away tyranny and give him the chance to die for his country. These poems ensured his immortality. Brooke became a figure of popular mythology, epitomising the many talented young men who sacrificed themselves for a war that had not yet become bogged down in the mud of the trenches. He was friendly with the leading literary figures of the day, including the bohemian Bloomsbury Set: poet W.B. Yeats described him as 'the handsomest young man in England'.

His good looks and artistic haircut probably helped to guarantee his posthumous popularity; the volumes of his poetry that were published after his death invariably carried this photograph on the cover. It is an image in striking contrast to contemporary 'men in the street', particularly after their locks were cropped short for the trenches. This curtained 'look' with a long divided fringe was revived in the 1980s when images of floppy haired young men, often dressed in white and posing in punts, appeared on many fashion pages, following the commercial success of that period's 'heritage' films. Still popular in London's banking sector, this Edwardian style retains its connotations of privilege.

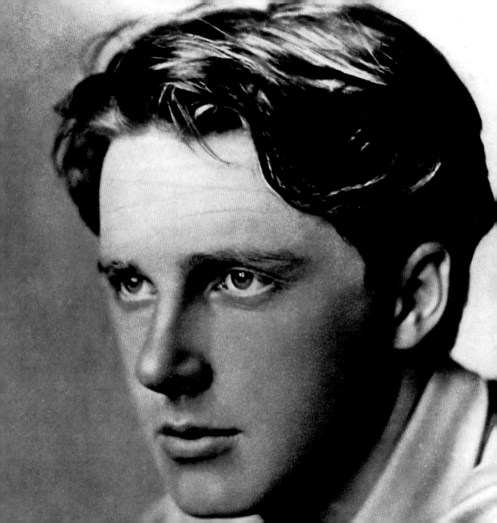

Rudolph Valentino

He was surely the most striking of the 'matinée idols' of silent cinema and when Valentino died of peritonitis in 1926 aged thirty-one, there were tearful women to be seen in streets across America, while his New York funeral attracted thousands of mourners. There was a second funeral in Beverley Hills – and even rumours of suicides among his legion of distraught female fans.

Born and educated in Italy, his dark good looks saw him cast, inevitably, as cinema's very first 'Latin Lover'. His most successful film was probably *The Sheik* (1921), based on a best-selling novel of the time; a young English woman, Lady Diana, is abducted by the handsome hero and so discovers true passion. Valentino's slick, elegant style inspired young men of the time to copy him. This meant, of course, the liberal use of whatever hair creams were currently available. Today, the selling of such products to men of all ages is taken for granted but it was Valentino who paved the way, even if the many who tried to copy his style were criticised and nicknamed 'Vaselinos'.

Women were already modelling their own looks on their favourite stars; Valentino was the first male star to act as inspiration and certainly not the last.

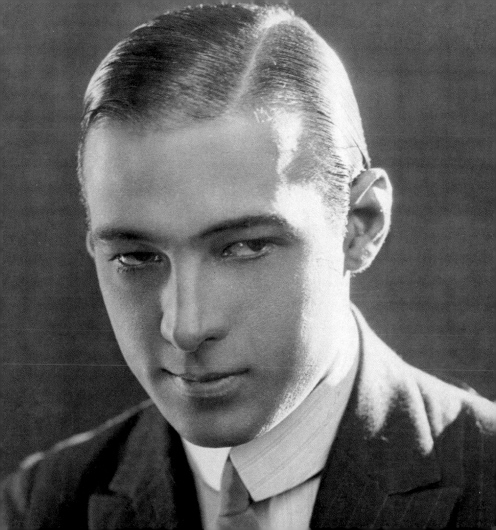

Louise Brooks: the Iconic Bob

Film star Louise Brooks was once cited by Anna Wintour, editor of American *Vogue*, as the inspiration for her own trademark bob. Brooks made her best films in Europe, working with directors such as G. W. Pabst: a publicity photograph taken in her European days could easily be mistaken for a picture of fashion designer Coco Chanel.

In addition to this most iconic of bobs, Brooks is here sporting a long row of pearls atop her 'Little Black Dress'. The bob, like the pearls and the 'LBD', now seems to be a chic perennial. Every so often a new incarnation will spark a revival, as happened with Uma Thurman's appearance in *Pulp Fiction* (1995) and more recently when Victoria Beckham chopped off her long locks, part of the 'footballer's wife' image she wanted to discard. It seems odd to think of this classic style as revolutionary, but in F. Scott Fitzgerald's 1920 short story 'Bernice Bobs Her Hair' the author presents his heroine as something of a scandalous trailblazer. However, by the mid-1920s the bob in its various forms was the dominant hairstyle and long hair was in retreat. Brooks's particularly short and stylish 'helmet' bob thus appeared at the end of a decade when the bob was just one sign of women pushing boundaries in taste and fashion.

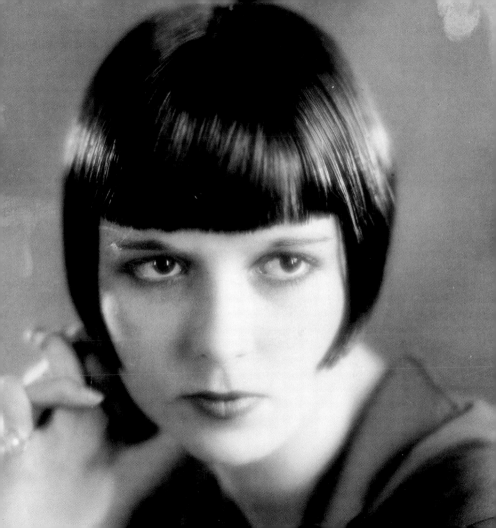

Marcel of Paris Beauty Shop

French hairdresser François Marcel is credited with the invention of the 'Marcel wave', a method of creating a long-lasting wave of the kind seen in this display first invented in the nineteenth century. This involved the use of heated curling irons. The irons used, soon exported across the globe, were originally heated over gas, but by the 1920s electric irons were available and their application became less hazardous. Marcel himself went on to develop a machine for 'permanent waving' and many other hairdressing implements, including different forms of hair curlers and pins.

The straight bobs of the early 1920s, as we have seen, delighted the fashionable but frightened the more conservative. However, short hair was acceptable to everyone if it was softened and made to seem more 'feminine' by the judicious use of a Marcel wave, a 'finger wave' and later a 'perm'. Short hair remained fashionable for the greater part of the twentieth century while long hair was associated with film-star glamour. Today, by contrast, long hair is far more popular and, just as in the Twenties, short hair is seen by many as too 'masculine'.

This branded store front, probably situated in an American high street, advertises many of the processes that made Marcel both famous and wealthy.

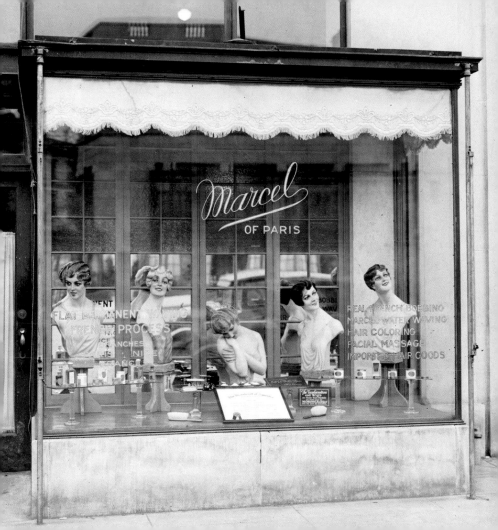

British Beauties

The picture shows us some 'British Beauties' of 1929. These girls are on their way to the Royal Albert Hall, contestants in the British Beauty Competition in a decade when such contests were establishing themselves.

The image shows how mainstream short hair had become, adopted now by all young women. Meanwhile, the growing popularity of the 'Marcel Wave' (see above) meant that the overall look could be softened or varied. The radical fashions of the early Twenties, the waistless fringed flapper dresses that typified the Jazz Age, gradually disappeared as the decade wore on and the economic situation worsened. This photograph was taken in the year of the Wall Street crash – hair was slightly longer and much softer, to reflect the new longer hemlines. Some fashion historians have suggested that short skirts indicate an era of economic prosperity, and that skirts always lengthen when the economic situation grows gloomier. The fur collars and jewellery we see here are quite conservative. Fitted dresses have returned, and the tightly fitted cloche hats that were worn over the shortest bob have also vanished.

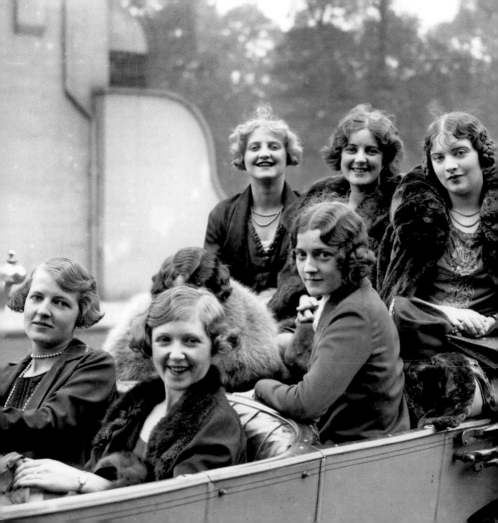

Antoine: Shingles, Curls and 'La Garçonne'

It was the Polish-born Parisian hair stylist Antoine (Cierplikowski) who had cut actress Eve Lavallière's hair into what was conceivably the very first bob in the first decade of the century. Yet in 1930 he was still a leading force in the hairdressing world after decades of innovations. The 'shingle' style, which first appeared in 1923, where bobbed hair is shaved into the nape of the neck, is credited to him. In England this variant on the bob actually prompted a music-hall song 'Bobbed or Shingled?' Antoine then went further, cutting women's hair as short as a boy's – this style was christened 'la garçonne' in Paris and the 'Eton Crop' after it crossed the English Channel. This last cut was so severe and so androgynous that it was pilloried in the press; there were quite a few cartoons in the satirical magazine *Punch*.

This picture shows an Antoine style of 1930, where he has softened the radical garçonne look with flat curls, referencing both the decade that had just ended and prefiguring that which would follow, when curls were once again an integral part of fashion vocabulary. Twenties film stars Clara Bow and a young Joan Crawford had sharp bobs – but from now on, Hollywood stars would soften their look with waves.

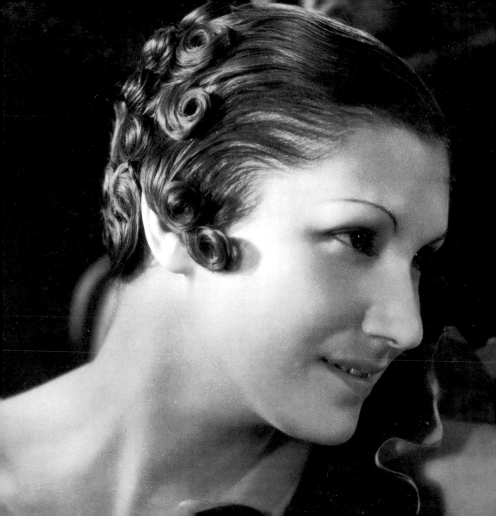

Learning to Perm

This terrifying machine looks like a medieval instrument of torture, while the white coats worn by the young women could suggest that some sinister medical experiment is in progress. The ladies watching are in fact hairdressing students at Barrett Street Trade School, later part of the London College of Fashion, being shown how to use one of the new perming machines, which were then appearing across the USA and Europe. Hairdressing was becoming a profession, and training was needed; it was seen as a sensible career for young women, even though most of the top stylists were men.

The permanent wave would soon take over from the Marcel wave and for decades many women would have a 'perm' every three months or so. Each week its shape might need to be retained by a trip to the salon for a 'shampoo and set'. In the 1950s home perms were introduced – waves and even curls were still seen as necessary – and lank, straight hair was seen as unsightly. By the 1960s, women grew their hair long again and some even ironed it straight, using brown paper and a domestic ironing board. Hair straighteners were on the market to stay. Today, the majority of women straighten their hair if it is naturally curly while many of us associate perms with the excesses of the 1980s.

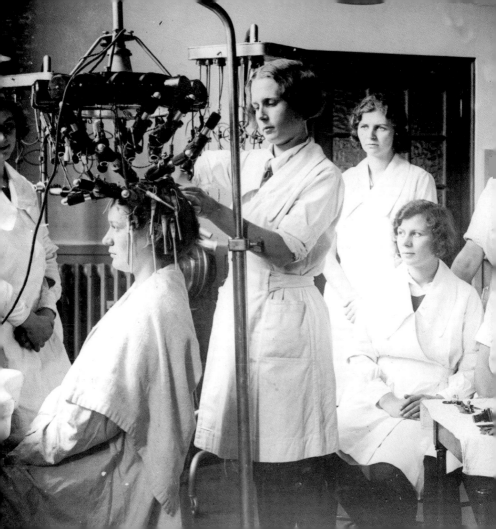

Jean Harlow, Platinum Blonde

One of the most influential of all screen stars, Jean Harlow was swiftly nicknamed the 'Platinum Blonde'. A talented actress with a particular flair for comedy, she appealed to women as much as she did to men. The satin bias-cut dresses which top designer Adrian created for her to wear in *Dinner at Eight* (1933) did much to make that particular style popular at mass market level – but it was her hair colour that provoked the most imitation. She is illustrated here in publicity artwork for war movie *Hell's Angels* (1930) kissing actor Ben Lyon.

She was the first leading actress to have what was obviously dyed hair – although in the preceding decade Clara Bow had given her 'flapper' bob an auburn hue with the use of henna. This natural product has been used for thousands of years – it was popular with the ancient Egyptians. It not only colours the hair but also is an excellent conditioner. Sadly, hydrogen peroxide is quite the reverse – and while Harlow's change of colour was supervised by studio stylists who could prevent real damage, there was no one to tend the thousands of women who experimented with bleach in their own homes.

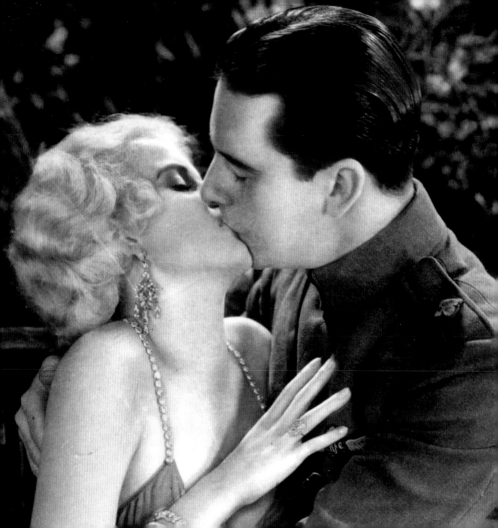

Hair Care and Beauty

Harlow's change of colour coincided with a surge in the number of home hair products appearing on the market. Many, like those seen here, were endorsed by actresses – some better known than others. However, there were also developments in and around hair salons. More and more new establishments were opening their doors to women, offering increasingly sophisticated and specialised treatments. They offered a growing range of new procedures and used the new technology now on offer – the still-familiar 'hood' hair dryer now made its appearance.

With the bewildering range of new products, both in salons and for use at home, there were obvious dangers. There was a sense that women needed protection after a series of accidents involving various cosmetic dyes intended for home use. In America, new legislation was introduced – the Federal Food, Drug and Cosmetic Act was passed in 1938 to make sure that there were some safeguards in place. This advertisement was placed in *True Story* magazine by the Jo-Cur Hair Care Company and published in New York City in 1931.

for ANY shade of HAIR

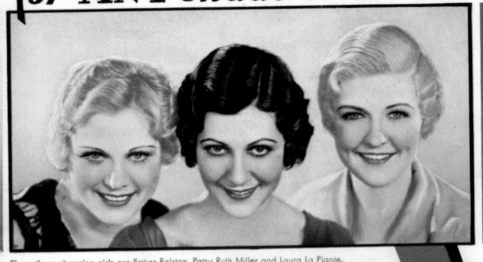

These three charming girls are Esther Ralston, Patsy Ruth Miller and Laura La Plante, all featured in the Pathe Feature Film, "Lonely Wives"

Quick, New Beauty!

NO matter what your shade of hair, you can quickly give it new charm and beauty by caring for it the Jo-cur' Way. It can always be soft, silky and lustrous—clean, fragrant and absolutely free from dandruff, with a lasting finger-wave that is simply fascinating! And you can do every bit of it at home—quickly—easily—and what's more, economically. First, a Hot Oil Treatment, that discourages dandruff, gives new health to the scalp —new life and youth to your hair. Then a fragrant, luxurious shampoo with Jo-cur' Shampoo Concentrate✿ gives your hair the fluffy softness, the satiny sheen that mean perfect cleanliness. Then a lovely, lasting wave with Jo-cur' Wave-set—the finger-waving liquid that sets alluring, natural-looking finger-waves for over a million women. And finally,

Modern Barbershop, Chicago

American men were also now offered new treatments in more sophisticated surroundings, as this picture of a brand new large-scale barbershop of 1931 – housed in the massive Art Deco Merchandise Mart building in Chicago – shows. But most men were not swayed by the gleaming gadgets seen here. They seemed to prefer the traditional local shop, where the proprietor knew his customers and their needs – which could extend to suggesting that the gentleman might possibly need 'something for the weekend'.

As hairdressing salons developed their technology and expertise, most women came to regard their weekly appointment with pleasure. But for the majority of men, until quite recently a haircut and a shave would ideally be carried out with minimum fuss on familiar terrain and not alongside so many others. That would certainly include banter with the barber and perhaps with other customers – but there was no sense of a need to be pampered or to experiment with new products. Perhaps that is why the small barbershop is still with us, and this gleaming behemoth is something of a historical curiosity.

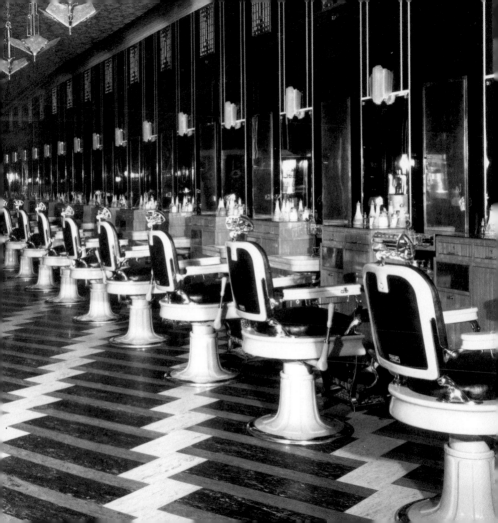

Ordinary Styles

This – presumably posed – portrait of an 'average' and prosperous American family shows us three people not, perhaps, in search of Hollywood glamour. It was mainly younger women who followed the changing styles of their favourite stars; this mother has unremarkable, neat hair with a modest wave. Interestingly her daughter is – without being aware of it – something of a trendsetter. This particular style for girls less than ten years old, a bob held in place by a wide ribbon, would linger on into the 1950s.

The father's choice of reading matter (*Advertising Age*), his suit, crisp-collared shirt and tie, all indicate that he is a sensible, successful professional man. He is certainly a regular visitor to his own local barber – that off-centre parting shows careful maintenance. Just above his lip, however, we see the slightest hint of a moustache, a facial feature that, thanks to the popularity of Clark Gable, was becoming fashionable at the time.

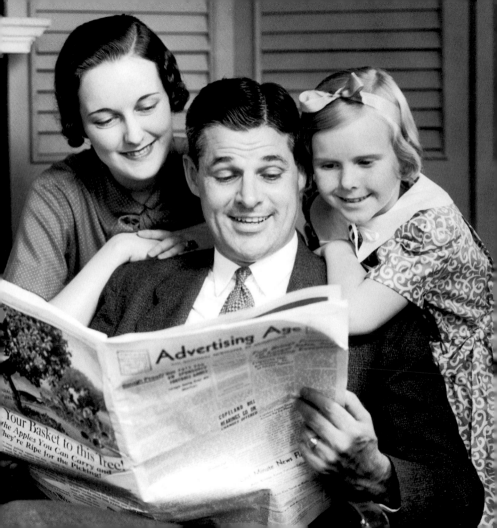

Sensible hair: the Snood

When a world war broke out once more, in 1939, governments on both sides of the Atlantic knew that women would again be needed in the workplace to help with the 'war effort'. This time they were employed in skilled factory work, as well as in munitions and on the land. Many more joined the women's branches of the armed forces; others volunteered as nurses or auxiliaries.

It was essential that they should be practically attired to avoid accidents, and of course their hair must be worn off the face – ideally tethered in some way. Audrey Withers, editor of British *Vogue* during the war years, has explained how the British government asked for the help of the fashion press in the promotion of practical styles. This snood, which was in fact enthusiastically adopted by young women, kept hair firmly out of harm's way; Britain's land girls had to make do with headscarves.

After the war, hairnets (made from a denser mesh than snoods) lingered on into the austerity Britain of the 1950s. By that time they had acquired a reputation for representing the very opposite of glamour. They were worn by female factory and catering workers for practical purposes – although we should note that Ena Sharples, the aggressive matriarch of British TV show *Coronation Street*, wore hers with pride at all times.

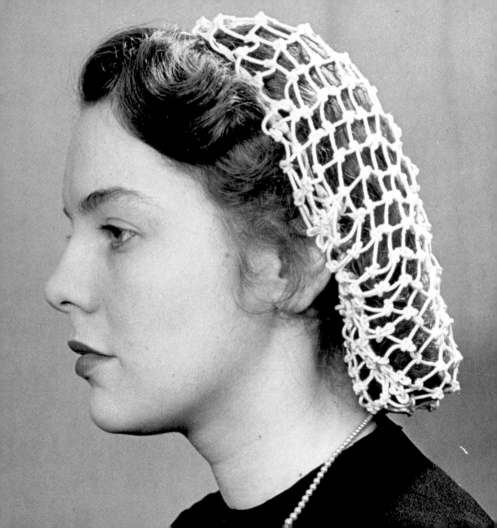

The Page Boy Haircut

Not all women were working – and even for those who were, there were the weekends, when they could dress differently, follow fashion and perhaps inject a little glamour into their lives. This 'page boy' haircut was seen on many film stars during the war years. Like the Edwardian 'pompadour' it needed a great deal of preparation – careful styling and dressing followed the preparatory curling and setting. Some young women even tucked small pads out of sight under the carefully set and rolled fringe to give it body and to ensure its stability. The style demonstrates that the wearer is prepared to spend time and effort on her appearance. As the war continued and shortages increased, austerity and hardship affected everyone. Clothes became practical and comfortable wedges replaced high heels; new outfits involved a skilful reworking of the old. But the raw material needed to create a new hairstyle was always available.

Another much simpler haircut for women – where the hair is cropped like that of a medieval monk – has also been called a 'pageboy', though in fact this style is closer to a bob. This cut here, however, has touches such as the high retracted fringe and generous rolls at the sides that look forward to some of the more glamorous styles of the late 1940s and 1950s.

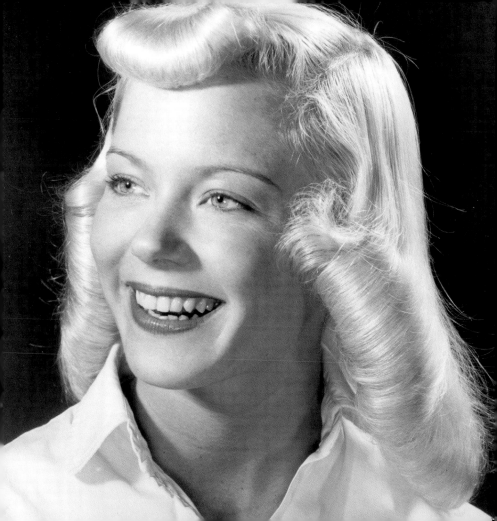

Veronica Lake: 'Peek-a-Boo'

Film star Veronica Lake, here posed on a fur rug complete with the stuffed head of a black panther, embodied a kind of feline glamour. It was her hair that accentuated this and created her characteristic look – she wore it falling across her face with a strategically placed wave beside one eye. This impractical 'peek-a-boo' hairstyle, as it was christened, was extraordinarily attractive to young women in the midst of wartime sobriety, and many sought to copy this style. It was not only deemed inappropriate – it was also extremely dangerous for those working with, or anywhere near, machinery. Once again the fashion editors were called into service, asked to decry the style and to emphasise the elegance of a turban. The turban won the day – as did another wartime hairstyle, the 'Victory Roll'. This involved the wrapping of long hair over a nylon stocking to create a roll like that of the 'pageboy' fringe, but a roll which extended all around the head. This style first appeared in 1943. It was both becoming and practical for women in uniform, forming a pleasing frame for their faces and a secure base for their 'forage' caps. It certainly added a touch of elegance for those who had to wear overalls – and perhaps made up for the fact that they could not copy Veronica Lake.

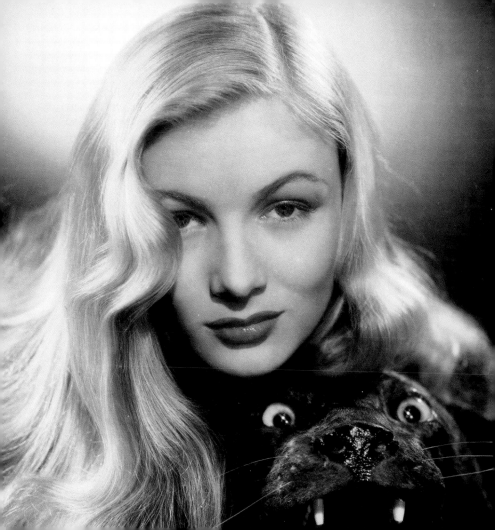

Rita Hayworth

Another glamorous film star of the war years, Rita Hayworth is pictured here in a figure-hugging sweater, a wartime fashion first popularised by Lana Turner. Above her forehead is a heavy curl, shaped into what seems to be a variant on the Victory Roll and her long hair is tamed into girlish curls, decorated with two child-like bows. This hairstyle and this picture were intended to evoke an image of a soldier's childhood sweetheart, the girl to whom he wanted to come home when the war finally ended.

When the war was over, Hayworth changed her style dramatically and this 'sweetheart' became the most famous screen vamp of all time in *Gilda*, released in 1947. In that film her hairstyle was more like that of Veronica Lake, and her mock striptease – which involved a pair of long black evening gloves – became part of cinematic history. Here, however, she is still posed as a beautiful version of everygirl, and shows us a hairstyle that young women everywhere might copy with the help of hairpins and their trusty curlers. Hayworth was also notoriously experimental when it came to hair colour, dying her dark brown hair red to become famous – and disguise her Mexican ancestry. She even became a blonde for husband Orson Welles' film, *The Lady from Shanghai* (1947).

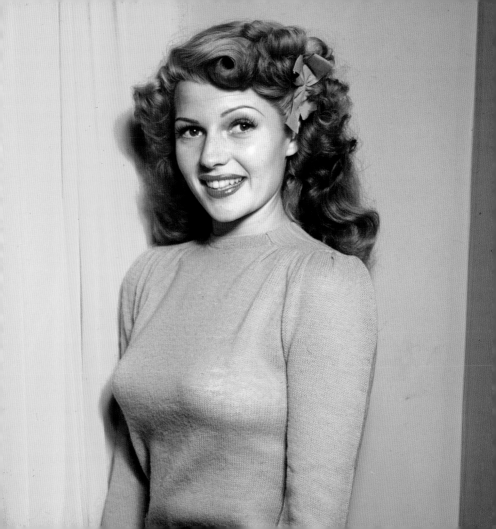

Hairstyle Competition in Paris

The postwar years saw various ways of celebrating style in Paris, which refused to cede its role as capital of fashion despite the privations the country was then suffering. Here we see not the couture show we might automatically associate with the city, but a hairdressing show and competition. This particular affair seems rather conservative in a year that saw the bikini launched nearby, at a swimming pool beside the Seine. The models being scrutinised here are showing off stiffly waved hair that seems to evoke the styles of the 1930s. They are surrounded by a panoply of male judges, who here and at beauty contests tended to secure these positions of power until the 1960s. However, the hair show and the hairdressing competition caught the imagination and they have remained a fixture within the profession throughout the century. Increasing in influence, they have gone on to develop closer links and formal relationships with the fashion industry. Since the 1960s hair shows have sought to showcase the innovative, the daring and the spectacular and are closer now to advertising 'events', to music videos and art exhibition openings. They have come a long way from the staid spectacle seen here. Yet to succeed at such an event is still the dream of many young hairdressers and awards are greatly prized.

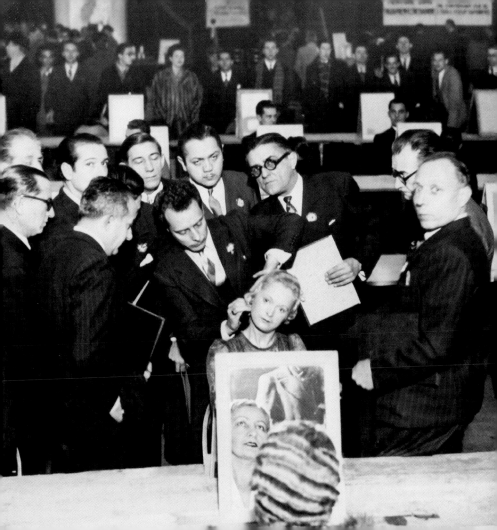

Sarah Vaughan

The jazz singer Sarah Vaughan, seen here in 1947, was popular in the post-war years. The 1940s saw some new developments in black style. Brightly coloured 'zoot suits' for men, with voluminous trousers that were gathered in at waist and ankle, appeared during the war; they were worn originally by African-American musicians in various cities across the United States. But for those in the public eye, conformity was the rule – so Vaughan straightened her hair, as did Billie Holiday throughout her career. Later, male musicians such as Little Richard, James Brown and Chuck Berry would first straighten their hair and then style it into a dramatic quiff or pompadour known as a 'conk'.

In his autobiography, Malcolm X describes the style of his wayward youth when he dyed his conk bright red and purchased his first zoot suit, a sky-blue number, at the age of fifteen. He rejected all of these accoutrements when he became a Black Muslim, seeing the straightening of hair and the adoption of lurid clothes as degrading to black people. Later Black Power activists would condemn hair straightening. Vaughan experimented with many hairstyles, long and short, including a 'pixie' cut with straightened hair similar to that adopted by actress Halle Berry in the early twenty-first century, as Bond girl Jinx Johnson.

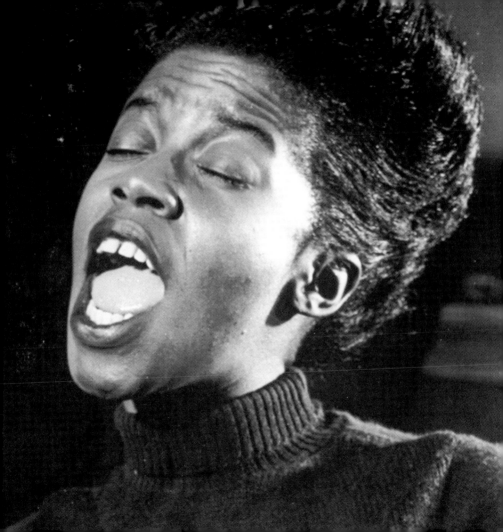

Jane Wyman

Some younger women in the 1940s and many in the decade to follow would seek out what we might now call 'alternative' styles. Some left their hair relatively straight and cut heavy fringes, known to many Americans as 'bangs'. (One explanation of this name is that it meant 'bang-off' – just straight across in front, as horses' tails are cut to a uniform length.) Here Jane Wyman shows off this style – to those who adopted it, it seemed more youthful than perms and stiff waves. In the 1940s and 1950s, the most radical young women copied what later became known as the beatnik style that emerged in the cafés and jazz cellars of Paris and New York. French singer Juliette Gréco let her hair fall long and completely straight over her shoulders, with a heavy fringe. To reject curls was one way of rejecting the rules.

Jane Wyman (at the time married to actor and President-to-be Ronald Reagan) sports a modified version of the look, for those American girls who would never get to Greenwich Village but who wanted to be seen as very slightly unconventional.

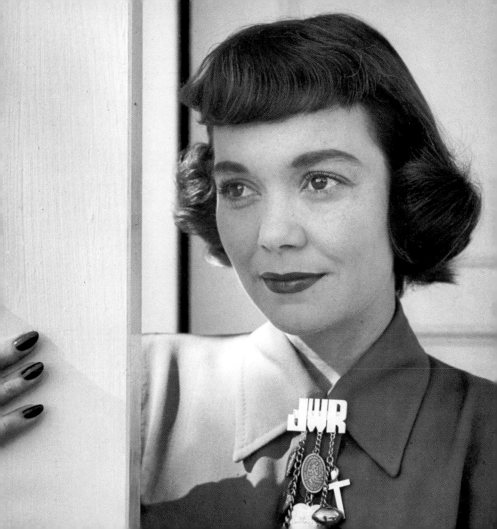

Audrey Hepburn

The much-discussed 'teenagers' wanted styles of their very own – carefully tended curls were too matronly and young girls experimented with other looks, including the ponytail. But Audrey Hepburn's gamine crop was for many the cut of choice. The film that made her a star was *Roman Holiday* (1953) in which she plays a frumpily dressed princess who escapes onto the stylish streets of Italy for a day of freedom. She transforms her appearance as she strolls across the city, swapping her court shoes for flat sandals purchased from a street stall, rolling up her sleeves and cinching in her waist. But the most telling part of her self-directed 'makeover' is her visit to the hairdresser. She persuades the young man to crop her long locks, and her trademark style was born.

Audrey kept this cut, short over the ears and with a heavy fringe for the subsequent films, which saw her dressed by Givenchy. On screen, however, she was also seen in outfits that appealed to her young female followers – black Capri pants, turtleneck tops and ballet pumps. These simple staples were part of her own personal wardrobe – and distinguished Italian shoemaker Salvatore Ferragamo christened a flat pump 'the Audrey' in her honour.

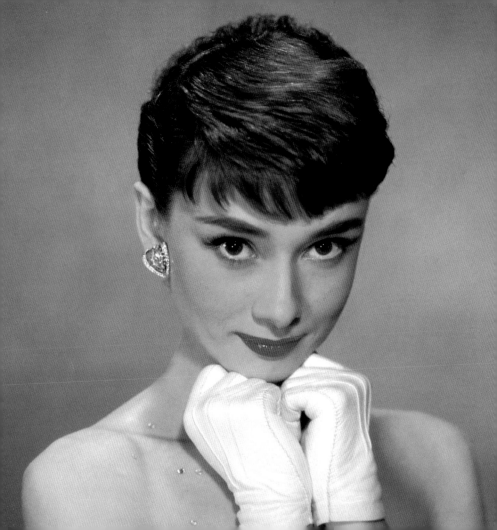

Mr Teasy Weasy at Work

Paris had the celebrity hairdresser Alexandre and Londoners had 'Mr Teasy Weasy', whose real name was Raymond Bessone. His salon in Knightsbridge was as flamboyant as the man himself, complete with gilt chairs, chandeliers and even champagne fountains. He affected a fake French accent and attracted many well-known clients, including film star Diana Dors, herself promoted as Britain's answer to Marilyn Monroe. She flew him over to America to style her hair, causing a great stir in the press.

He was most famous for the backcombing he deployed to build hair into the 'bouffant' style that he is usually credited with inventing. The style was popular well into the Sixties, with women from different social and ethnic backgrounds. The most successful black girl group of the time, the Supremes, had bouffant hairdos.

Mr Teasy Weasy was very skilled at self-promotion and he helped to make hairdressing both commercial and competitive. He created a chain of salons in London and the provinces, while commanding his own regular slot on television.

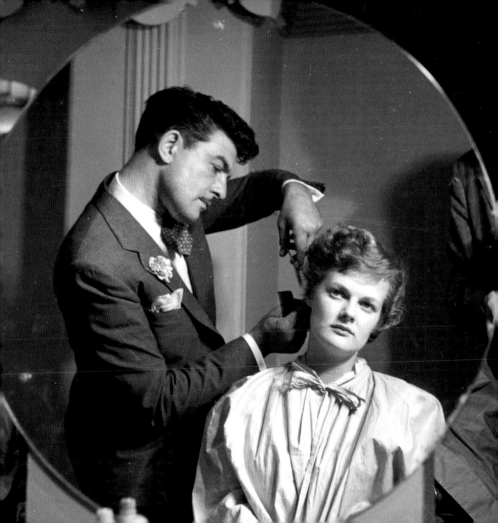


April 1953

Alexandre de Paris: Celebrity Stylist

The celebrity hairstylist returned in the postwar years. Paris, which had formerly been ruled by 'Antoine', had in Louis Alexandre Ramon – always nicknamed 'Alexandre de Paris' – a new, undisputed king. The writer Jean Cocteau gave him the nickname 'the sphinx of hairdressing' and women would fly over to Paris simply to have their hair styled by Alexandre. Possibly his most publicised task was the creation of Elizabeth Taylor's various 'looks' for the film *Cleopatra* in 1963. Taylor continued to employ him after the filming – he was also the hairdresser whom Greta Garbo and Lauren Bacall visited regularly.

But he was not simply a Hollywood hairdresser; he was the choice of those in haute couture. His predecessor Antoine had tended the hair of Coco Chanel herself – Alexandre was the hairdresser used at catwalk shows when Karl Lagerfeld succeeded Coco at Chanel and he also styled the shows of the fastidious Yves St Laurent. Suzy Menkes, of the *International Herald Tribune*, has been a leading force in fashion journalism since the 1970s. Alexandre created her signature hairstyle, a pompadour, and she would fly to Paris so that he might tend to it himself until his retirement from the profession. In this image he is styling hair to be worn at a ball given by the redoubtable Elsa Maxwell, American society hostess and gossip columnist.

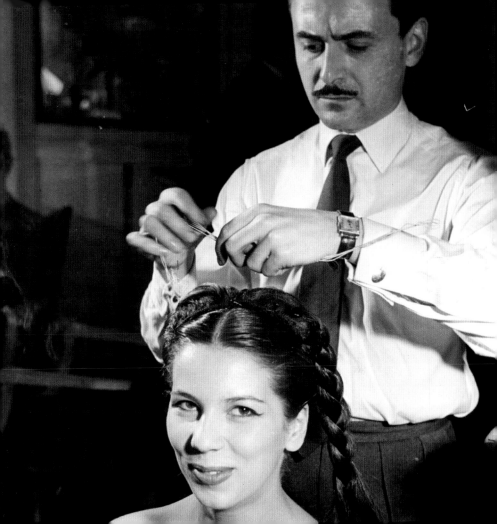

Evening Chic: Dior's New Look

The most influential of all postwar fashions was Christian Dior's 'New Look' collection of 1947 and this picture shows that, eight year later, it still influenced eveningwear. Dior decided that women wanted romance, nostalgia and a new sense of femininity after the horrors of war. So he rescued women from their utilitarian clothes and practical trousers; he offered instead to imprison them in clothes that were almost Edwardian in their impracticality. Clothes were so snugly fitted to the body beneath that 'waist-cinchers' – abbreviated versions of corsets – were an integral part of the 'look'. Skirts were long, even for day, and were either very, very full or pencil-slim. Heels were high, handbags and hats were tiny. Evening gowns were low-cut and backless with heavily boned bodices. The toilette was completed with relatively simple but elegant hairstyles, either wound up into a chignon or softly waved off the face.

Despite the restrictive nature of this New Look, Dior had gauged the mood correctly. Women loved these clothes and copies of his designs swept across the high streets of Europe and America. Here these young women show off their small waists and their hair is carefully dressed. One is holding up her skirt – this was often necessary with these gowns, since ease of movement was not part of Dior's agenda.

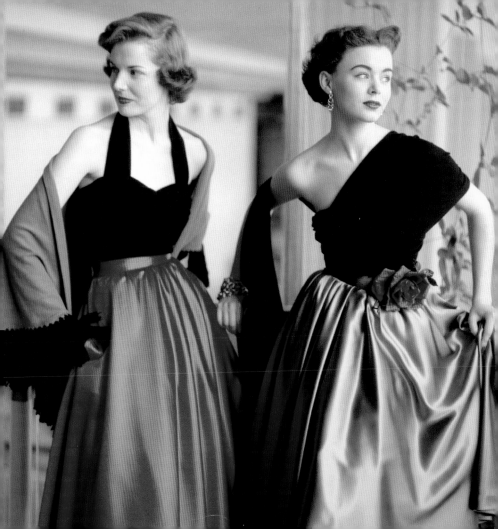

James Dean

If teenage girls now had Audrey Hepburn's style to copy, boys then and forever after would look to twenty-four-year-old James Dean. The Teddy Boys had their elaborate quiffs and the GIs their semi-shaven heads, but Dean offered a different look both in hair and clothes that became 'fashion classics'. Taking his cue from rock 'n' roll styling but with less 'grease' and pompadour-laden mass, Dean took this look out of music and subculture and onto the cinema screen – without losing attitude along the way.

When studying at the Actors' Studio in New York, he and his colleague Marlon Brando bought their clothes from army outlets and thrift shops. They chose leather jackets, lumberjack shirts, Army greatcoats and – most famously – white T-shirts. Until this last garment appeared on screen, it had simply been a humble sleeved undervest, intended for use under a battledress. Its most iconic moment was its appearance on the poster for *Rebel Without a Cause* (1955) the last film Dean ever completed. Released after his death in a car crash, it ensured not only his own immortality as an icon, but the enduring potency of his outfit and of the simple waved hairstyle seen here. This picture was taken while filming *Giant*, which was released in 1956 after his death.

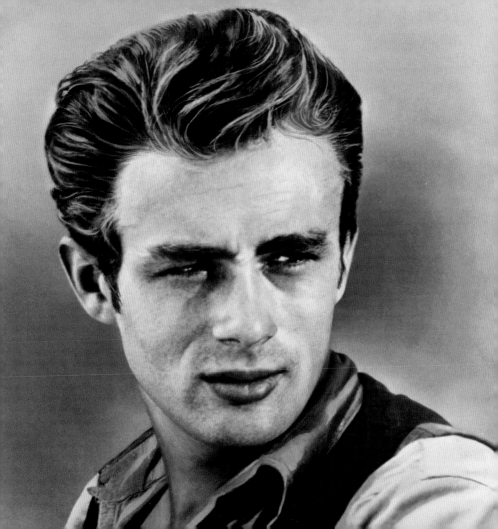

Tony Curtis

By the second half of the decade, younger men had a variety of new hairstyles from which to choose. The young actor Tony Curtis was credited with popularising the 'Italian cut' seen here, a kind of ruffled wedge. He also brought the DA – or 'duck's arse' – into the public consciousness; here, the hair was cut short into the neck, but for a tiny pointed sliver, left longer, which curved downwards.

Italian style was what most fashion-conscious young men sought; they wanted snappy tailoring and continental sweaters, short jackets with two vents, narrow trousers and perhaps pointed shoes. The young 'modernists' who emerged at the end of the decade, their nickname showing that they listened to 'modern' rather than 'traditional' jazz, were the real champions of this look. They were also the inspiration and forerunners of Sixties 'mods'.

Philadelphia stylist Joseph Cirello is said to have created the DA in 1940 – though he originally called it the 'Swing' in homage to jazzman Benny Goodman, before it acquired its more famous moniker. Elvis Presley was said to have copied Curtis's DA and so made it even more famous, more desirable.

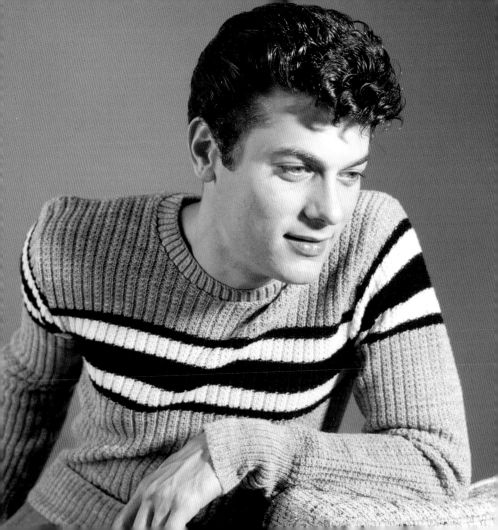

Mirror, Mirror

In the 1950s, a very feminine idea of elegance – with a touch of accessible glamour – was heavily promoted by middle-class women's magazines, who offered endless hints on how to achieve the desired look. The advertisers of the period provided further examples and instructions. But there was nothing really 'accessible' about the glamour of Marilyn Monroe, the most famous film star of the decade. Nevertheless, women copied her make-up and above all her hairstyle, the Italian 'demi-wave'. This we see here; for several years, it was the most popular style on both sides of the Atlantic.

These women are dressed in fitted, full-skirted frocks accessorised with carefully chosen, affordable necklaces and matching earrings. The blonde girl wears a necklace consisting of three strands of graduated fake pearls, seen on many women of the time – and deplored by teenagers as a sign of conformity. Both models here have plucked their eyebrows into a slender arch like those of Marilyn – the thicker brows of Audrey Hepburn are copied by the younger model on the right.

Military Crew Cuts and Buzz Cuts

During the Second World War, American 'G.Is' (short for 'government issue') first became a familiar sight in Europe – and during the Cold War, which followed; they were stationed there for the next twenty years or more. In England, they were criticised at first as 'oversexed and over here'. One reason for this distrust was their comparative affluence and their ability to please the young women they courted by offering them fashionable items not available in this country, and compared to many of the locals they did embody confidence, swagger and style. (This photo shows marines enjoying a cigar at Marine Corps Basic School.)

But the 1950s brought well-paid employment for the newly identified 'teenagers', and many of them looked to America for their music and their visual inspiration. America came to mean rock 'n' roll, blue jeans and radical haircuts for teenagers who wanted to be different. Young men emulated the 'crew cuts' and the 'buzz cuts', which for American servicemen were simply a matter of necessity. The press was full of pictures of Elvis having his trademark quiff shaved when in 1958 he was called up for National Service. This simply made the shorn look still more popular. The GI look has remained (with minor modifications) a staple haircut for civilians ever since, experiencing regular revivals in popularity.

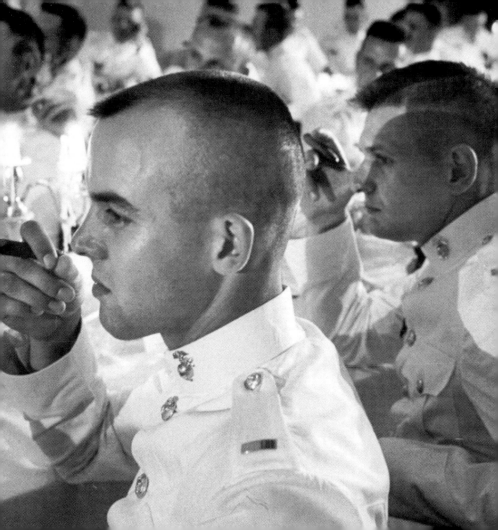

Wash-and-Wear Wigs

Hair does not always conform or behave – it won't always do what its owner wants, nor let the hairdressers and stylists have their way. The next decade saw the widespread adoption of the new synthetic wigs, which were promoted with the slogan 'wash and wear'. Formerly, wigs and hairpieces had been prohibitively expensive – but synthetic fibres now put them within the reach of many women.

Here, Eurasian actress France Nuyen is wearing just such a wig, which has been set in a style like that seen on all-American girl and popular young screen star Debbie Reynolds. Wigs could transform a woman's appearance; so could long hairpieces and they too were soon on sale. They remained popular well into the next decade. They completely transformed scanty locks – today, extensions are employed for that purpose. Wigs, hairpieces and extensions can also create a kind of cultural uniformity, as here, where the actress's ethnic origins are disguised and a kind of 'whiteness' superimposed. And the renewed popularity of wigs in the early 1960s was a sign that big (or bigger) hair would be back, at least for a while.

Jacqueline Kennedy

Jacqueline Kennedy was one of the most influential fashion icons of the early Sixties. The pillbox hats she wore, and the collarless coats-over – dresses that Oleg Cassini created for her, were widely copied. It was not only the Americans who adored her. When she accompanied President Kennedy on a state visit to Paris, the French press featured every outfit in which she appeared.

Her hairdresser was 'Mr Kenneth' (Kenneth Battelle) who had many other celebrity clients. Jackie Kennedy, however, was the most high profile. Mr Kenneth was nicknamed the 'American Secretary of State for Grooming' and advocated the use of big rollers for creating waves that did not look artificial. He was also credited for restoring Marilyn Monroe's hair from the ravages of overperming and bleaching.

The look he created for the young President's wife, and which she hardly varied for the rest of her life, was a 'soft' version of the popular 'bouffant', combed off the face and gently curling up at the sides. It was the perfect hairstyle for a woman whose much-praised and constantly copied style was simple, streamlined and classic.

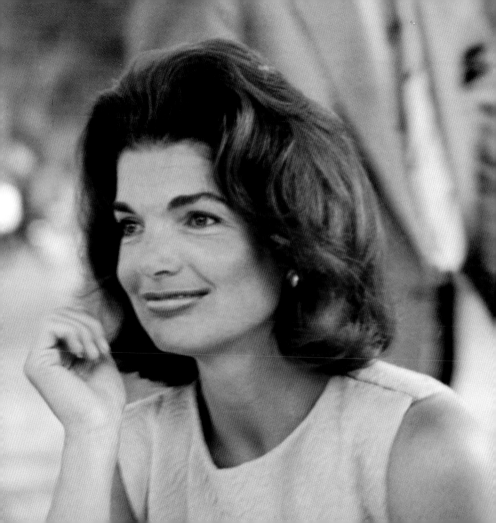

Helena Rubinstein Salon

Most older women in the Sixties continued to make their weekly trips to the salon for their 'shampoo and set'. This picture shows the splendours of Helena Rubinstein's palatial premises on New York's Fifth Avenue. While only the rich and privileged sat on the leather seats pictured here, hair-dryers very like these made their way across the Atlantic. More and more salons invested in the state-of-the-art machinery now on the market.

The women here have the chance of a manicure while they sit under the hood of the dryer; the small 'vanity units' we see here, and their attendant wheeled stools, would soon appear in London salons and spread across the country.

Polish-born Rubinstein had been an active beauty and cosmetics entrepreneur in the USA since the Teens and during the 1960s had a range of luxury salons. Although not exactly 'The Woman Who Invented Beauty' (the title of her biography) she made women far more conscious of their appearance. She used anxiety, pseudoscience, and high prices to capture her clientele, and was said to have coined the phrase: 'There are no ugly women, only lazy ones.' Rubinstein died four years after this photo was taken and her company was subsequently taken over by L'Oréal.

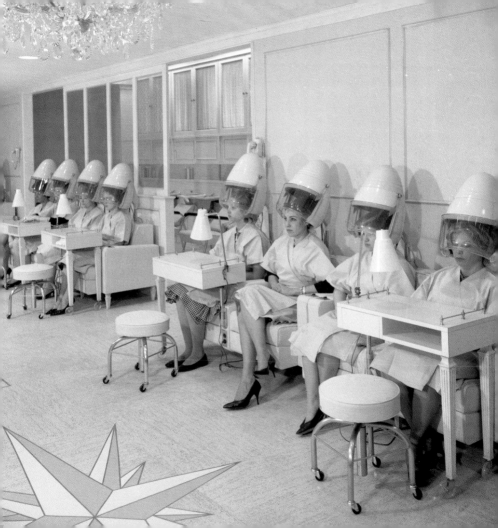

Hairdressing Contests: the Beehive

Hairdressing competitions were not the exclusive preserve of well-known hairdressers in capital cities. They were becoming popular everywhere. Here we see a young local hairdresser trying her luck and showing off her skills. Susan Ramsden, a stylist from Sussex, wears her own hair in a fuller version of Jackie Kennedy's bouffant. However, she has exaggerated 'flick-ups' at the sides, very popular among younger women. These were 'set' on large rollers and then secured with a liberal application of hairspray.

She is arranging her client's hair into a version of the 'beehive' hairdo then popular on both sides of the Atlantic. It was created in America in 1960 by a Chicago hairdresser – many saw it at the time as a modern-day version of Marie Antoinette's high-piled 'pouf' hairstyle, though the hairstyle now epitomises the 1960s. The Ronettes, the black girl group masterminded by Phil Spector, were famous for their towering beehives and recently the style was revived by British singer, Amy Winehouse. Sixties singer Dusty Springfield was a great fan of the beehive – and she also liked thick black eyeliner, just like that worn by Susan's anonymous model.

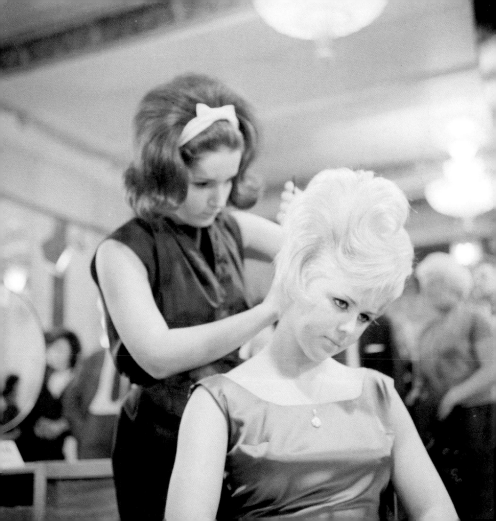

Vidal Sassoon

Vidal Sassoon was an East End boy who learned his skills at Mr Teasy Weasy's Knightsbridge salon and retired to California a millionaire. He was arguably the most influential of all celebrity hairdressers. What Sassoon understood was that the new youth-oriented fashions of the Sixties needed a different approach to hairstyling. The new outline was streamlined and body-skimming; clothes swung slightly when the wearers moved and so, he thought, should their hair. So he concentrated on the cut, creating a simple geometric bob that only needed a blow-dry with a handheld dryer and allowed the hair to fall naturally into place. By 1965 he opened a New York salon, and the franchise spread swiftly across the globe. Later there would be Sassoon hair products.

Diana Vreeland, editor of American *Vogue*, coined the expression 'youthquake' to describe the changes of the Sixties. Previously, most young women had dressed to look older than their years. The desire for elegance was replaced by a wish to look 'trendy'. And trendy women all had their hair cut by Vidal himself – designer Mary Quant, French fashion designer Emmanuelle Khanh (pictured here), actresses like Julie Christie. The weekly 'shampoo and set' became the provenance of the middle-aged: younger women and the fashion-conscious would go to the salon for a cut and blow-dry, as they do today.

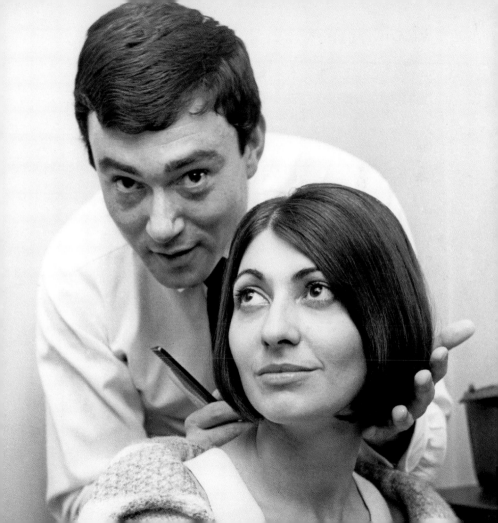

Mod Style: the Small Faces

For a short while London was the centre of global trends and the place that all young people wanted to visit. In a decade when music came to dominate the lives of young people, British bands were very much to the fore. And for the 'mods' of the Sixties, the right haircut was vital. Here the quintessential mod band, the Small Faces, show how haircuts had evolved by 1966. Mod culture was always male-dominated and -driven – the girls danced at the edges of the hall, while the boys strutted their stuff at the very centre. Mods rode Italian scooters while their enemies, the Rockers (still with their quiffs) had British-built motorbikes.

The Beatles' 'mop tops' of the early Sixties were seen by the stylish as very commercial – there were even Beatles wigs on sale. In the early years of the decade, mods adopted a very short 'Roman' haircut, like that seen on classical statues, to accompany their Italian clothes. But hair grew gradually longer as the decade progressed and the mood changed. Here their look involves a centre parting and a carefully cut fringe – later, the mods would grow the sides longer while still leaving the top short.

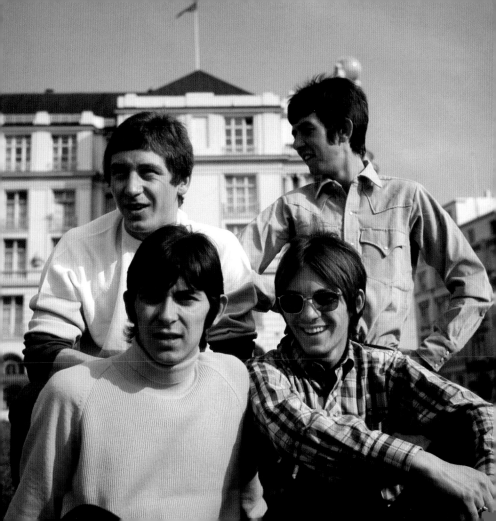

Rolling Stones Fans: Hair Goes Long

By the last year of the Sixties, hair had become even longer. Most young people of both sexes grew their hair slightly and some let it become very long indeed. Students and musicians did not have the tiresome dress codes of the average workplace to observe. Everyone in this picture (male or female) has longer hair, even if it is just a matter of heavier fringes and covered ears – a trend that would last well into the early 1970s. The word 'unisex' had entered the collective consciousness and soon 'unisex salons' would appear.

These fans are in Hyde Park for the Stones' famous 'free concert', where Mick Jagger released a crowd of white butterflies and recited a poem by Shelley in a tribute to Brian Jones. More controversially, he wore a white tunic from a London boutique that looked to many observers exactly like a dress. Five fans here are wearing headbands – this accessory was another sign of what was now called the 'counterculture', critical of contemporary society and mass consumerism, including its elaborate hairdos and ostentatious displays of wealth. During this period long hair with a simple centre parting (perhaps with a rustic braid for girls) was taken up as a more natural and unaffected style. It was adopted by fans of folk and flower power and others who just liked the look.

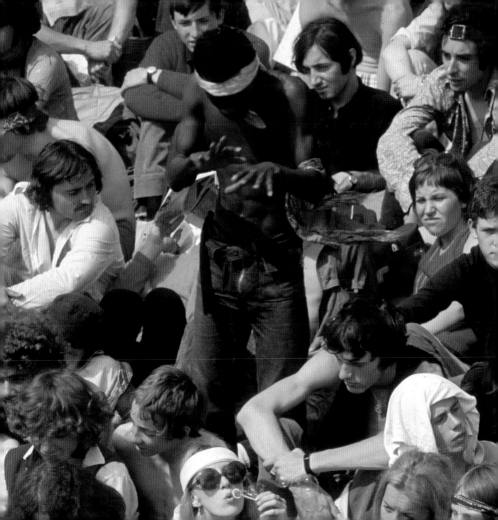

The Afro: Marsha Hunt

Marsha Hunt was also in Hyde Park – she was then starring in the London production of the countercultural musical *Hair*, famous for its moment of total onstage nudity. Every night, members of the audience were invited up to dance with the cast – Princess Anne herself accepted that invitation. The late Sixties saw student protests and mass demonstrations against the escalating American involvement in the Vietnam War. In America there were other forms of revolt. The Civil Rights movement had met with some success, while the Black Panthers demanded more substantial, speedier changes and the first Women's Liberation march took place on the West Coast of America in 1967.

Hair was often a clear sign of commitment to a radical cause. White student activists grew their hair as long as they could. The Afro style that Marsha Hunt adopted, where black hair is permitted to grow naturally without straightening, plaiting or braiding, became a badge of ethnic pride. Hunt and the American activist Angela Davis and many soul musicians sported this style: it was not seen as threatening. It was more dramatic gestures like the Black Power salute at the 1968 Olympics and arguments from the likes of Davis which continued to shift the political terrain.

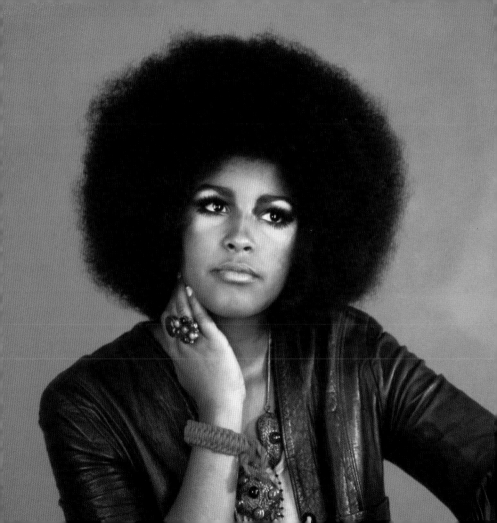

Glam Locks and Looks: Marc Bolan

As the Seventies opened, some musicians now flirted still further with androgyny and started to wear deliberately visible make-up. Marc Bolan of T. Rex was one of the first; he decorated his face with tiny silver stars and used kohl to outline his eyes. Here, he wears a leopard-print jacket and an Aztec necklace, chosen to feminise his appearance even more. Rising star David Bowie dyed his hair bright red and wore a one-shouldered leotard to match.

Soon many mainstream bands were adopting this look, which became known as 'glam rock'. Men in heavy make-up and high platform boots could be seen each week on pop music shows. Men whose hair didn't curl like Bolan's could now get a 'perm' at the unisex salons which were opening across the country. The make-up they would have to find for themselves.

The fashion for male perms continued in the late 1970s with white sportsmen like British soccer player Kevin Keegan being particularly responsive to the trend. Female perms also staged a renaissance in the 1980s with androgynous styling. They retain their presence in the margins to this day.

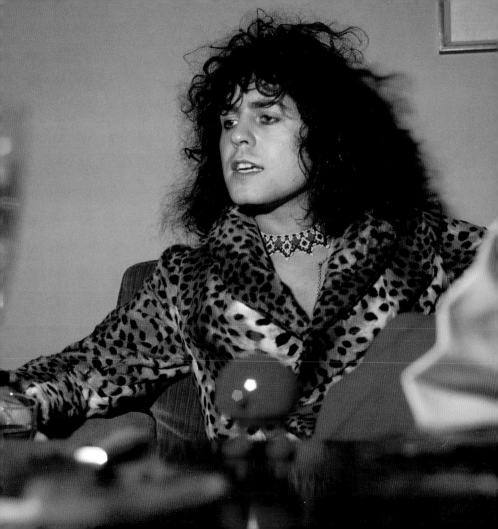

The Farrah Flip

It was not only film stars and musicians who inspired hairstyles and trends. More and more, people took their cues from the small screen as television took up its place as another showcase of styles to copy. Former model and poster girl Farrah Fawcett Majors appeared in an American crime drama series, *Charlie's Angels*, first screened in 1976. Her heavy, swept-back fringe and tumbling waves of blonde hair caught the eye and the imagination. Young women now hunted out heated rollers and some had soft perms in their desire to emulate what was the style of the decade for so many. It was nicknamed the 'Farrah Flip' and the owner of this enviable mane was swiftly signed up – to promote hair products.

Charlie's Angels was a spectacular success across the world – there were endless spin-off products and tie-ins, just as in the heyday of Hollywood. There were in fact three 'Angels', but it was Farrah – and her hair – that people noticed. She would go on to appear in films and to act off-Broadway – but she could never escape the part with which she was identified. More accurately, she could never escape identification with her Seventies hairdo, a fact to which she alluded sadly for the rest of her life.

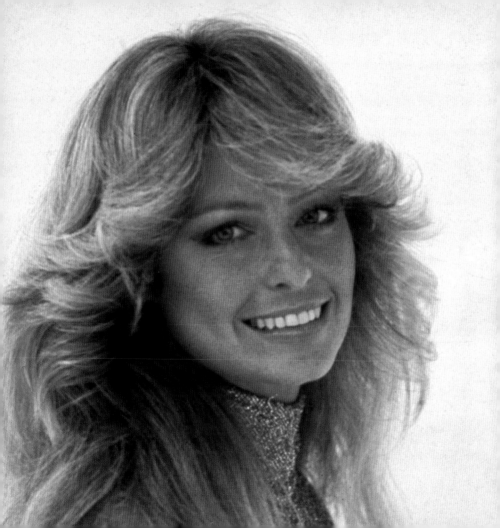

Punk and Mohawks

As the optimism of the Sixties receded, a reaction was inevitable. Punks appeared in London in the mid-Seventies, a harsh antidote to the soft charms of glam rock. Their clothing was designed to provoke and to offend if possible – they sported Nazi insignia, neck tattoos, nose rings and heavy boots. But the main statement was made through their hairstyles. Many spiked their hair up into a style dubbed the Mohawk (or 'Mohican' in the UK); this meant the creation of a crest like that seen here, through the use of whatever fixatives gave the desired result. Some used glue, others egg white. Often the crest was dyed a lurid colour, intentionally confrontational. The boy behind has created a number of separate spikes, fanning out around his head, illustrating another option. Girls also took on the spiky punk look with figureheads like Soo Catwoman and her distinctive 'cats' ears' style as well as musicians like Siouxsie Sioux. Early punks were visible from around 1975. By the time of this photo, such hairstyles were well established if not exactly routine.

Subsequently the mowhawk style has been picked up by everyone from 'goths' to soccer player David Beckham with numerous variants – almost all of them at least slightly anti-establishment – including the 'fauxhawk' where the sides of the head are short but not shaved.

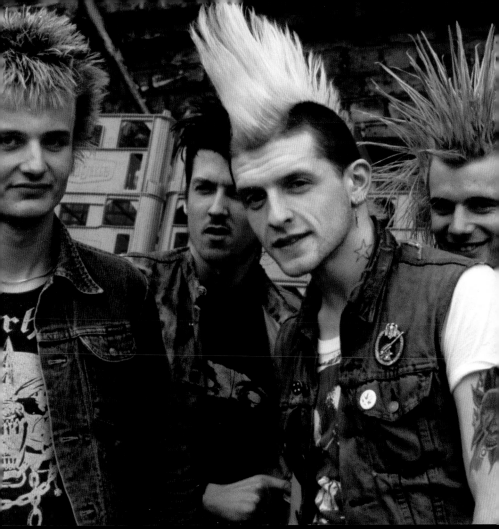

New Romantics: Duran Duran

The early 1980s saw another sartorial reaction among young people, this time a revolt against the aggressive aesthetic of punk. Young musicians and London's fashionable club-goers now wanted a return to glamour and the result was the brief reign of the so-called 'New Romantics'. Male dandyism and dressing up were back, along with eyeliner and lipstick for men – clothes were flamboyant and flashier hairstyles reflected the new mood. The five members of Duran Duran, seen here, were quite mild in their dress and self-presentation compared to David Sylvian of the band Japan and, of course, to Boy George, the first man to appear on the cover of Australian *Vogue*.

But we nevertheless note their carefully applied pale lipstick, necklaces and artfully tousled fringes – the streaked tips sported by singer Simon le Bon (on the right on the back) were widely copied. Wham, the duo in which George Michael made his musical debut, went further and actually frosted the tips of their softly permed hair as hair styling products for men gained in popularity. Boys could have fun once again – even if too many ended up with the haircut known as a 'mullet', short on sides and front and long at the back, still worn by some fans of heavy rock to this day.

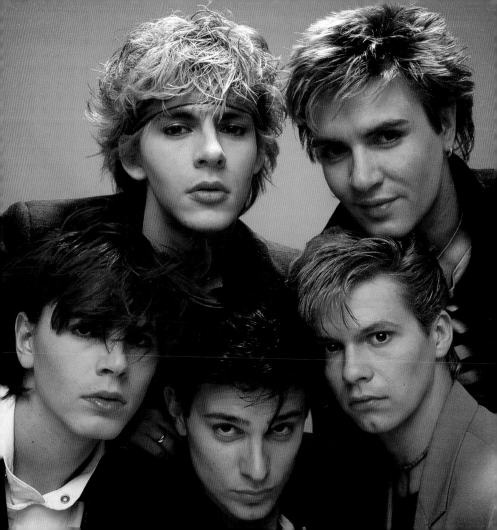

Princess Di

The early years of the 1980s saw the emergence of a royal superstar, who swiftly became the darling of the British media and then a global celebrity. Diana Spencer, an aristocratic part-time nursery school teacher just out of her teens, became engaged to Prince Charles, heir to the throne. The press loved Diana at once – she was pretty, photogenic and clearly had a sense of humour. She also had a style of her own, putting her personal spin on the 'Sloane Ranger' style of her peers. From the beginning, her clothes were copied.

But it was Diana's heavy side-swept fringe that seemed to epitomise her look and which appealed to women of all ages. In the UK film *Educating Rita* the heroine, a provincial hairdresser played by Julie Walters, is presented with a picture of Diana by a malevolent-looking client in her forties who announces firmly, 'I want to look like this'. She was not the only one.

Every new outfit with which Diana experimented was featured in the press, but her hairstyle she changed more rarely. However, she famously cut her hair very short after her divorce and her seeming expulsion from the Royal Family. When Diana died in a car crash aged thirty-six, the extraordinary scenes across the country revealed the true extent of her popularity.

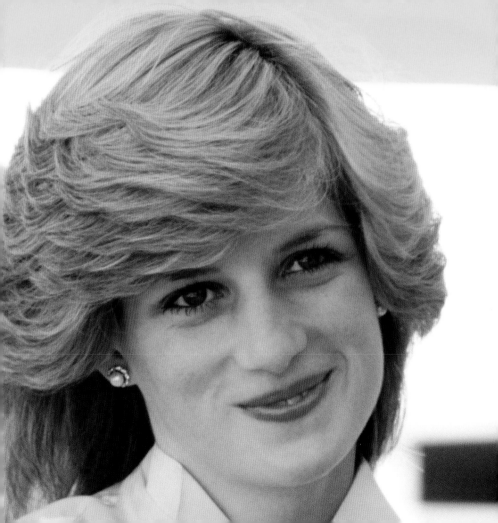

Cornrows and Dreads: Stevie Wonder

The Eighties saw the emergence and the triumph of new forms of black music in America. Most rap stars were male – their clothes and their hairstyles gradually filtered into the mainstream on both sides of the Atlantic and were popular with white boys, too. Their baseball caps, originally worn back to front, were easy to emulate, while their designer sportswear was widely coveted. These new black stars showed off their wealth and their new power through the luxury brands they wore, while their heavy gold chains showed the meaning of the expression 'ghetto fabulous'.

Pride in their ethnic origins saw African-American musicians adopting traditional African hairstyles – hair was plaited into tight 'cornrows', grown and then twisted into dreadlocks or braided and ornamented, as seen here on Stevie Wonder. The bikini-clad white actress Bo Derek, star of the film *10*, had her hair plaited in cornrows. The style has remained popular with young people looking for an eye-catching way to dress their hair.

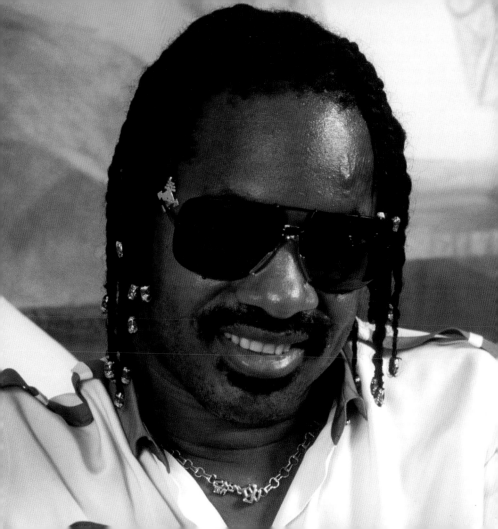

Big Hair, Small Screen

The most popular television programmes of the early Eighties were *Dallas* and *Dynasty*, soap operas that followed the fortunes of rich and constantly feuding families involved in the oil business. The clothes of the *Dynasty* stars, Joan Collins and Linda Evans, were spectacular, as was their 'big' hair, carefully dressed to emphasise their wealth and power. Lisa Whelchel's rich, spoilt-girl character Blair Warner in the US TV comedy series *The Facts of Life* is partially true to this type. Her character's long hair, its volume amplified by hairspray (or gel) and with generous waves and curls, seems to sum up the styling excesses of this particular time.

But the second half of the decade saw the popularity of more down-to-earth soap operas, with realistic, recognisable characters and storylines. *Neighbours* was set in a fictional Australian suburb and the young Kylie Minogue found fame playing Charlene. Twenty million viewers in the UK watched her character marry her boyfriend, Scott (played by Jason Donovan). Many in the army of fans who adored Kylie copied her long permed locks. But for many fastidious viewers, the frizzy perms of the Eighties were anathema and gave the poor 'perm' a bad reputation that has remained with us.

Catwalk Shows

Catwalk shows were once the preserve of the ultra-privileged. They were exclusive affairs and only invited couture customers usually attended the small shows in salons. There was no publicity. But as couture customers decreased radically in number after the 1960s, the well-known design houses became more competitive. Publicity was vital and the catwalk shows became larger and increasingly more spectacular. By the 1980s there was also a growing public interest in luxury brands and a new awareness of 'high fashion'. Media coverage has increased across the subsequent decades, as the invited celebrities now seated on fashion's famous 'front rows' ensure the attentions of the paparazzi.

Shows became of interest not just for the clothes on the catwalk, but for the often extravagant hairstyles and make-up created especially for each event by leading stylists – including such names as Trevor Sorbie and James Brown, famous for his professional relationship with model Kate Moss.

The new trends in hair became part of the coverage expected from the shows. The fashion and beauty pages of the glossy magazines are now given over to catwalk style after each round of runway shows is over. Couture clothes may be difficult to copy, but hairstyles are not. The crop shown here (central) and the nape-tied ponytail (left) may look dated now, but in the Eighties they probably had their fans.

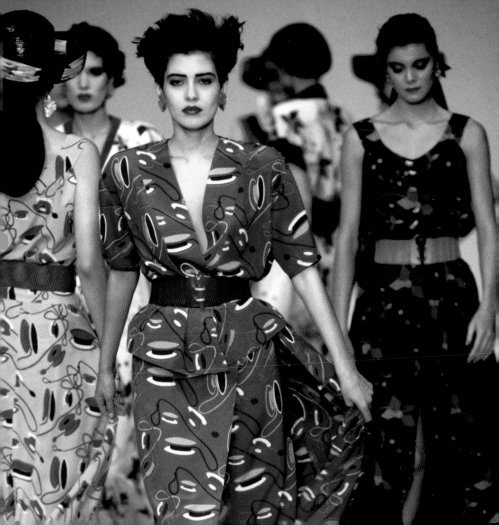

The Rachel

Friends was first screened in 1994, a sitcom about six young people in Manhattan who shared two flats and various adventures. It finished ten years later but had a seven-year afterlife in reruns on cable and satellite channels the world over. Jennifer Aniston played Rachel, who during the series succeeded within the fashion industry after a disastrous spell as a waitress. In the closing episodes she was offered – and accepted – a job at Louis Vuitton in Paris. But famously, in a dramatic finale, Rachel chose instead to stay with Ross, her on-off boyfriend and the father of her child.

Rachel had a memorable haircut – a choppy layered bob. This was created for Aniston by her long-term stylist Chris Macmillan and she kept the look for the first two seasons. Yet she disliked it and has frequently spoken of her misgivings about it. Nevertheless, viewers loved it and the 'Rachel' cut was the most sought-after style of the 1990s.

Aniston speedily became and still remains an A-list celebrity: her shorter style was swiftly replaced by the long, straight glossy mane that seems to be an essential component of the contemporary celebrity look.

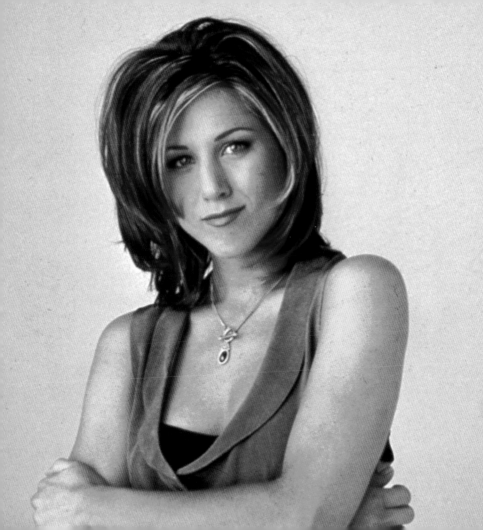

Hairstyle in the City

Four years after *Friends* first aired, its popularity was challenged by another American series showing the adventures of a group of friends in New York. But *Sex and the City* was very different. It too was a comedy but infinitely more hard-hitting and quite graphic in its discussion and portrayal of contemporary sexual relationships. It showed the very tangible struggles of the four women at its centre as they tried to find success at work and in their private lives. Sarah Jessica Parker who played the narrator, Carrie, had a quirky way of dressing which made the actress something of a fashion icon. She popularised the hairstyle seen here – long and loose with the dark roots intentionally on view. Parker's wavy dirty blonde look often involved the heavy use of a crimper, slightly at odds with a wider trend towards straightening hair that has dominated the last decade.

As the show became more and more popular, so it became increasingly a show watched for its fashion. Stylist Patricia Field began by dressing her characters in a mixture of contemporary clothes and the vintage styles she favoured. But she found herself inundated with requests from well-known designers who wanted their clothes to appear on the show – and, ideally, to be worn by Carrie.

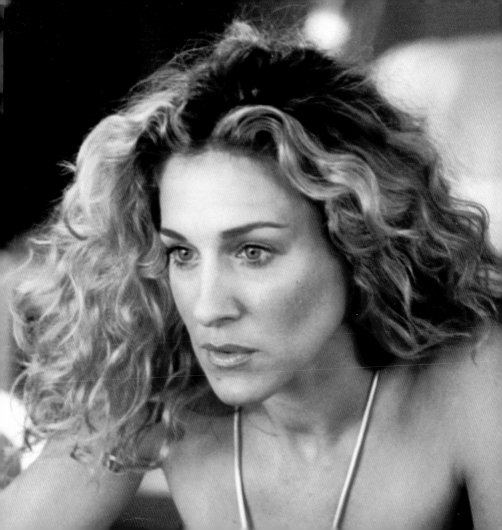

David Beckham, Metrosexuality Personified

8 August 2002

David Beckham moved from being England soccer captain to become the epitome of modern 'metrosexual' man – he is now, after his retirement from the pitch, a global celebrity noted for his fashion sense. He gradually became as famous for his various haircuts as his dead ball skills. Some saw him at first as a fashion victim, particularly given his famous sighting in a sarong. But undeterred, Beckham experimented with a new style every few months and each one found its followers. He had floppy 'curtains' around his face reminiscent of Rupert Brooke, gelled locks that recalled Valentino, an aggressively shaved skinhead crop, a mullet, cornrow plaits, and various hair bands that came and went. Beckham changed the colour of his hair as often as its shape and the choppy near-mullet shown here was Beckham at his blondest. Not all his experiments were a success – but each one was spectacular and made the press. He was signed up to advertise anything and everything that might appeal to young men, including grooming products for the hair. Most of all he was proof that it was fine – even cool – for men to experiment with their hair.

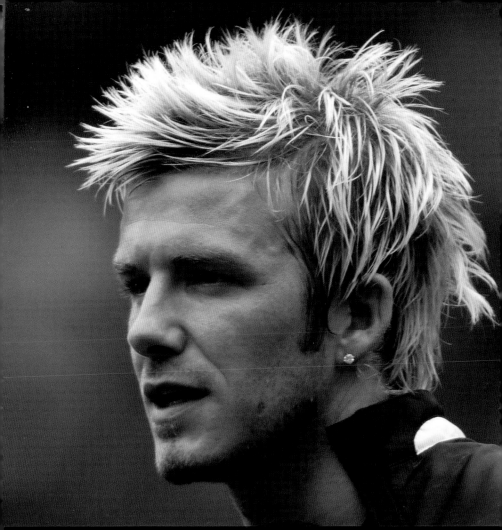

Emo and its Aftermath

Subcultures surface on a regular basis, and each time a fashion-friendly look appears, its taming for mainstream consumption is inevitable. But nevertheless, young people still strive to hang on to their own originality and authenticity. The 'grunge' style of the 1990s, which began among the bands in Seattle, famously found itself on the catwalk at Perry Ellis in New York in 1993 and the young designer responsible, Marc Jacobs, was instantly fired. But neither the style nor Jacobs went away.

The emo and goth looks that followed grunge and eventually filtered into fashion consciousness originally saw musicians and their followers dying their hair and straightening it firmly so that it fell heavily across and around their very pale faces, often parted well to the side as if to minimise eye contact. Here we see its legacy – these girls, the Australian singing duo known as the Veronicas, give the look a vampish spin with even more exaggerated eye make-up and visible fishnets. There is also a 1920s feel to their outfits. While there's relatively little connection with the original grunge look, contemporary hairstyles constantly borrow elements from both the recent and the more distant past.

Contemporary Retro Hairstyles

Today, fashion seems frightened of looking forward, and so designers endlessly recycle images from the past, referencing and mixing up different decades and creating a kind of postmodern mélange. Here we see a high-piled hairstyle evoking the early Sixties but worn with the 'cat's eye' spectacles that were fashionable in the Fifties, while the pale lipstick provides a modern feel.

Interestingly, although the Sixties is the decade revived most often and most enthusiastically, the futuristic designs from the early years of that decade have been ignored. No one has chosen to recycle the white 'space-age' boots and tunics designed by Courrèges or the innovative plastics used in different ways by Paco Rabanne. But many of the hairstyles have been revisited – just minus the backcombing and heavy lacquer.

A revival usually means a reworking with a careful nod to modern sensibilities – the television series *Mad Men* is a perfect example of this. The production designer for the series has presented the clothes and décor of the past with what seems at first to be complete accuracy but there are various subtle differences intended to make it attractive to a contemporary palate. Not every past style becomes widely fashionable again – surely the voluptuous Gibson Girl look with its elaborate coiffure will not reappear in the fashion pages again, a hundred years after its heyday?

Acknowledgements

The Author and Publisher would also like to thank the organisations which have facilitated the use of illustrations, credited below. Every attempt has been made by the Publishers to secure the appropriate permissions for materials reproduced in this book. If there has been any oversight we will be happy to rectify the situation and a written submission should be made to the Publishers. Wherever possible correct dates have been given accurate to the day or month or year/s of the original photo to the best of the Publisher's knowledge.

All images including cover courtesy of Getty Images except for p.29 ©London College of Fashion; p.35 and p.73 Library of Congress.

Index